baby Jesus

W9-CFZ-696

angel

star

Jesus

Jesus

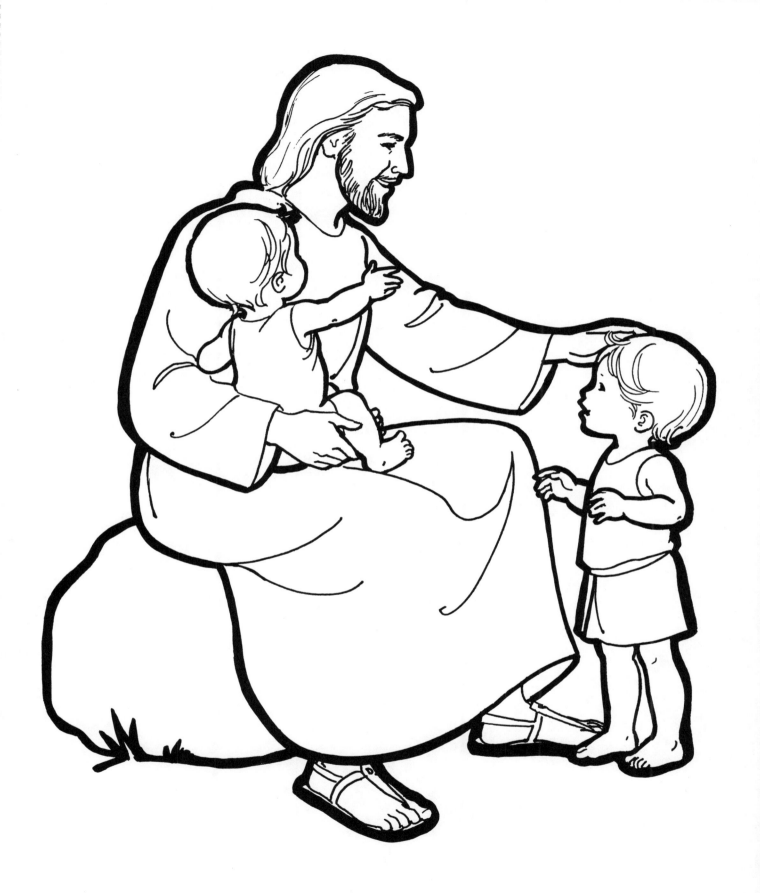

Jesus and children

child

bird

bird

bird

Bible-times house

Bible

church

child

child

baby

mother and daddy

daddy and child

family

family

God made my mouth.

God made my eyes.

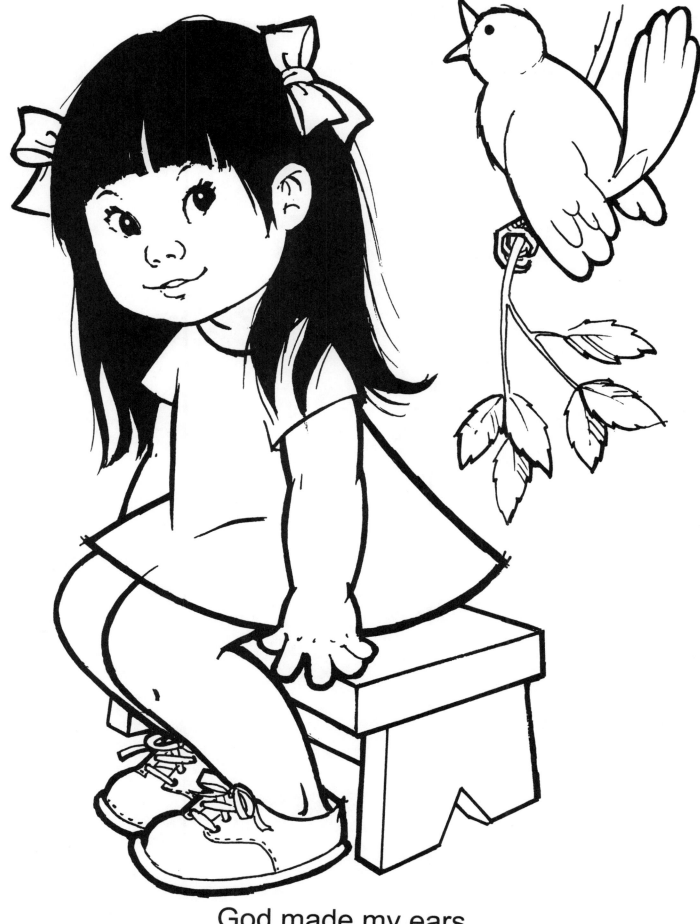

God made my ears.

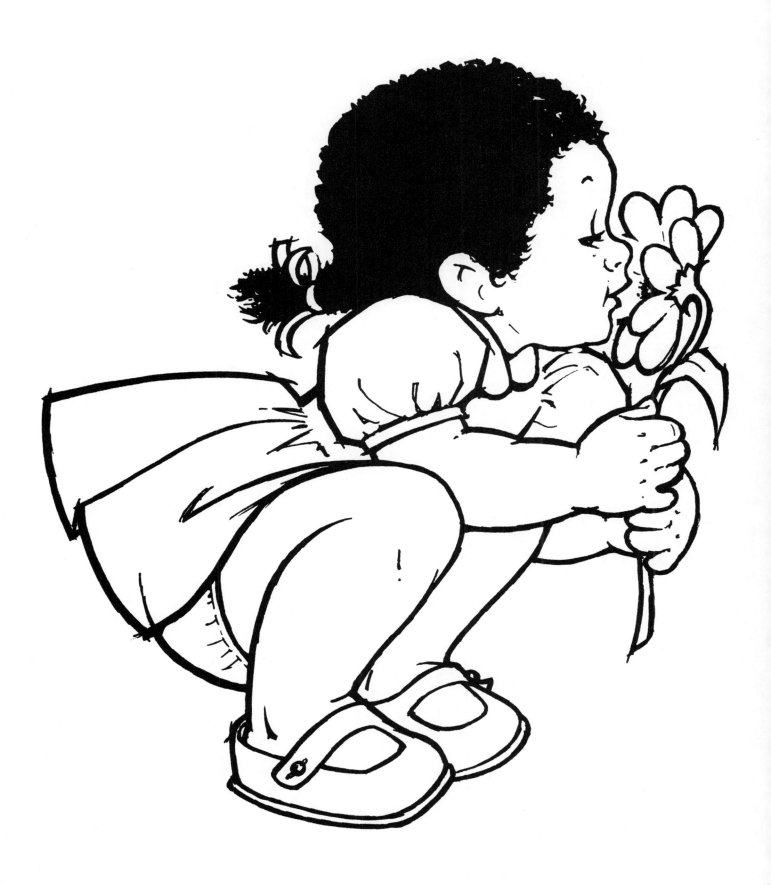

God made my nose.

God made my arms and hands.

God made my legs and feet.

dog

mother cat and kittens

flower